**Books are to be returned on or before
the last date below.**

23. FEB 2006

−3 OCT 2011

D1493218

LIBREX —

UNIVERSE OF FASHION

SONIA RYKIEL

BY PATRICK MAURIÈS

UNIVERSE / VENDOME

First published in the United States of America in 1998
by UNIVERSE PUBLISHING
A Division of Rizzoli International Publications, Inc.
300 Park Avenue South
New York, NY 10010

and

THE VENDOME PRESS

©1998 Éditions Assouline, Paris
English translation copyright ©1998 Universe Publishing

Front cover photograph: striped knit tops and knit skirt, Spring/Summer 1987. © Dominique Isserman.

Back cover photograph: Sonia Rykiel, February 1982.
© Dominique Isserman.

Text and captions translated by Cynthia Calder

ISBN: 0-7893-0204-7

Printed and bound in Italy

Library of Congress Catalog Card Number: 98-060239

Foreword

Sonia Rykiel, that small-boned woman with the recognizable head of red hair, has been a friend to women all over the world. To quote Rykiel, "It took me ten years to define a style, ten years to define an image, and ten years to re-define the woman's role."

Her first sweater, <u>the</u> sweater, a Rykiel signature piece, was designed and developed in 1962, and sold in a shop named Laura on the road to Orly. In 1968, she opened a small shop on the Left Bank, in the heart of the Saint Germain-des-Près district, where fashion editors flocked to see her collections. How the press suffered—the heat was torturous, the seats small and cramped, and not a window in sight. We sat rump to rump, uncomfortable but devoted. Fears of claustrophobia couldn't dissuade us, and as soon as the ready-to-wear collection week was over, we ran back to the shop.

Rykiel did define a style. Indeed, Rykiel was the essence of the woman whose role she sought to define.

As you will see in this book, Sonia Rykiel's career traces the beginning and the growth of French ready-to-wear. Rykiel has taken part in it all. She was the first fashion designer to create clothes exclusively for a mail-order catalog, 3 Suisses. She has launched a perfume; she has participated in the French runway presentations each season. A recipient of many awards, she has been acclaimed by fashion magazines around the world, by stores around the world, and by women around the world.

Rykiel has always been an independent, creative force, one who is never directed by the hype of fashion. Does Rykiel design for herself as women designers are said to do? Perhaps. Her petite frame might be the model for those small sweaters and dresses. Her international business might have made her aware of the need for seasonless clothes, for clothes that travel. Who knows? Does it matter?

This book introduces you to the Sonia Rykiel you probably know only by label. She is a woman you will be very pleased to meet.

<div align="right">

Grace Mirabella

</div>

One day in 1962 a well-bred young woman with fiery red hair expressed a wish. Her husband's boutique sold clothing that ranged somewhere between the custom-made and the ready-to-wear. She asked one of his suppliers to make up a special wool sweater, just for her, along with the stock produced for the shop. Slightly cropped, fitted, in pale gray. This woman was young and inexperienced. She had faced few real challenges in her life. Born into an upper-middle-class family, one of five sisters (who engaged in the usual mother-daughter conflicts), she had always planned to devote herself to having several children, bringing them up well, reading, going to the theater, and enjoying a busy social life. The sweater went through alteration after alteration—first she insisted it was too long, then too short, the armholes weren't right, etc. It went back and forth between Venice and Paris seven times

before the design was perfected. Like the plot of a fairy tale, this garment created a charmed existence for Sonia Rykiel. Featured on the cover of *Elle*, snapped up by the American market, the design was a spectacular success, forging the destiny of its designer and transforming her name into one of the most distinguished labels in postwar French design.

the plot continues: the outline of her remarkable story tracked the creative surge of the last thirty years. With the onset of the 1960s came a new mood in design, a fresh alternative to both the rituals of haute couture and to the more accessible approach of the neighborhood dressmaker, whose designs were faint echoes of Parisian styles. There were shifts in the economics of households; the last vestiges of postwar austerity had disappeared; France was acquiring a fresh self-image with its new-found wealth. As tissue-paper sewing patterns disappeared from ladies journals, ready-to-wear styles emerged, a fundamental element of modern fashion. It was just at this moment that the "accident" of the wool sweater occurred. Sonia Rykiel was unaware that she had entered the world of design at the same time that Gérard Pipart, Emmanuelle Kahn, and others had begun their fashion story; fashion was being recreated in step with a new world order. Eschewing the ceremony surrounding limited production lines and the exorbitant prices of haute couture, free of the constraints imposed by unique or limited custom designs (a problem common to both haute couture and the neighborhood dressmaker), they introduced the concepts of mass production, affordable prices, and quality on a grand scale. At the same time, a pivotal new figure emerged: the designer. Subsequent developments

have reinforced these themes. Certain traditional elements of fashion became dominant at the expense of others: the image of the creator, an essential aspect of identifying a label; the relentless timing of new collections, systematically feeding a growing number of boutiques; the runway rituals, fodder for the media, where hype eventually overwhelmed the original objectives. No one better exemplifies these changes than Sonia Rykiel. There are two main reasons behind her success: the intelligence with which she established and diversified her line, and her resistance to the gradual dilution experienced by the first ready-to-wear firms. Sonia Rykiel had a willingness as well as an ability to capture the moment—to hear the beat. Furthermore, unlike many, if not most of her competitors, Rykiel has never "lent" her name to an outside party. She never agreed to act as the creative spirit behind another label or design house, always presenting designs under her own name. This philosophy is vital, as will be seen, in explaining the scope of her activities as well as ultimately defining their practical limitations.

Let us briefly outline the rise of this successful career. Rykiel's fateful boutique, called 'Laura', was located on the road to Orly airport, and this fortuitous location explains in part the speed with which her first legendary sweater caught on. Within five years, the first sphere of influence and an international clientele had begun to take shape. In May 1968 she decided to set up shop on rue de Grenelle, helping to pave the way for the Saint-Germain of the 1970s. A hotbed of innovation, it became the center of lively activity and dizzying pleasure that attracted the

international in flocks: Andy Warhol lived on rue du Cherche-Midi; David Hockney moved from London to the Cour de Rohan; Shirley Goldfarb was a regular at Café de Flore's sidewalk terrace, where Roland Barthes routinely appeared around 7:00 P.M.; the Givaudan boutique on boulevard Saint-Germain sold the first funk music recordings along with underground New York magazines; Kashiyama displayed the first Jean-Paul Gaultier creations; Karl Lagerfeld's designs for Chloé donned the shop window on rue de Gribeauval; Donna Jordan and Jane Forth, the top models of the day, pirouetted in front of The Drugstore in Warhol and Morissey's *L'Amour*. This was the beginning of an era of styles and fashionable haunts where anything was possible; there was a carefree euphoria in the air, a feeling of general liberation that inspired creativity. And at the Rykiel boutique, books written by her friends were displayed next to her own first designs, reflecting the desire to juxtapose genres, to open new spaces, to reshape the image of the body, to affirm the powers of seduction and the delights of materials. A paradoxical mixture of cerebral and sensuous pleasures.

things progressed very quickly. The drama of the moment was nourished by an endless succession of new names and styles. But the real creators, although icons of today's media industry, were just beginning to gain recognition. In 1973, Sonia Rykiel, who hardly conformed to the strict conventions of the business, was elected vice president of the couturiers' and fashion designers' union. The union had been formed to defend the fashion designers' interests, regulate the rules governing the still tame world of presentations and fashion shows, and define the limits of the newly emerging profession. She was to hold this position for

twenty years. Other highlights: in 1977, true to her convictions and her concept of fashion, she prepared a collection of clothes for large-scale distribution. Designing for a *3 Suisses* catalogue might have seemed incongruous, in conflict with the mystique of "exclusive" creations. Instead, she became the leader of a new, alternative form of distribution. She had set an example that was followed over the years by numerous designers and couturiers—including, recently, Yves Saint Laurent.

everyone knows the importance of perfumes to a label's visibility and economics. Rykiel's first fragrance was created under license in 1978. A line of children's clothes was followed five or six years later by the launch of "Inscription Rykiel"; then came a menswear line in 1989 and 1990. A new perfume was launched in 1993 just before the opening of a flagship store on boulevard Saint-Germain, a logical conclusion to the journey begun twenty years earlier at rue de Grenelle. And finally a boutique on Madison Avenue in 1996.

The speed of this development seemed to keep pace with the trends of the period—the irresistible and intriguing rise in the power of the fashion world, the unfettered growth of labels and fashion companies, the tragicomic devotion to fashion designers as heroes and style innovators, the elevation of models to fashion icons alongside the famous actresses of the day.

One overriding factor of utmost importance drove these developments: the ever-growing fascination with fashion was driven primarily by consumer appetite, reflected in sales revenues. The scale of the fashion business soon attracted the attention of industrial groups and conglomerates that nourished and accelerated

the extraordinary demand, acting as both the cause and effect of growth. A variety of names became involved, all operating under the influence of the international groups that underwrote their activities. Rykiel steered clear of this approach; the trajectory of her career reflected her own choices, marked by a sort of personal intuition that allowed her to work within the accepted universal laws of marketing, or around them.

Sonia Rykiel's universe is utterly feminine, persistently autobiographical. Her work is like a novel in which she is the main character. Few designers have so clearly made the story of their family life the center of their creative activities. "I always focused on women—my mother, my sisters, my friends or myself. It was obvious since we were involved in the same discussions, the same situations, the same styles. We had the same approach to life, our children, the men, the house, the world, politics, pleasures."

Rykiel lived through extraordinary times: the breakdown of traditional roles, the redefinition of masculinity and femininity, a new set of social expectations, shifting perspectives on the responsibilities of motherhood, the acknowledged longing for liberation—in short, a redefinition of the rules governing society. Over the course of twenty years, we have come to understand the effects and limitations of this turmoil. In *Collection Rykiel*, one of the books describing this period, she states: "It took me ten years to define a style, ten years to define an image, and ten years to redefine this woman's role."

The intensely personal aspect of her creativity lends itself to a collection with broad applicability. The woman that she represents

is "liberated," in every sense of the word; as never before, she has escaped the clutches of the past and has redrawn the boundaries of her supposed nature. She has picked up where the revolution begun in the twenties left off and carries it onward; women of her generation will take credit for ending elitism, making diversity their characteristic value. There is, for example, no conflict between body and mind; this woman can wryly call herself an intellectual. She has a unique profile in history—just a few decades of the twentieth century—marked by high standards, curiosity, a sort of intellectual generosity, longing, and a desire for frank conversation and discussion. She is characterized, above all, by an open mind. A captivating reader who aimed to charm and whose every activity was rooted in her various pieces of handiwork.

"Using fabrics, colors, shapes, I wrote a journal, a history. The story of an actress, part imaginary, part real, a sophisticated nomad who plays and changes shape, who sows and plants, alights and then takes wing. All this is just words, but that is how it is inside-out and right-side-out. I layered, then ripped out hems, shortened, then shortened again. I worked with the living body. I knew there were codes, precise requirements that can't be deployed without study and technical expertise. I didn't know how it was supposed to be done—I used my own methods."

hence, another unique aspect of Rykiel's style: her independence. She wasn't forced to succumb to the decrees of the "seasons" which are driven largely by business demands. A romantic, subjective person, she never heeded

the marching orders of the themes and slogans the media attaches to each collection. She has elaborated at length on this topic, going so far as to write a book called *Collection termineé, collection interminable*. As ongoing of course as the analysis that you undergo. "My clothes are not designed in stages, just in moments; I don't work that way, I play the role of a woman. No spectacles, no theater, except the fashion shows. I create the story day by day. A skirt, a sweater, a dress. One follows another like pages in a book; it works like a novel. But I wouldn't be able to tell you who the novelist is or where the story is set. I make corrections, I delete, I turn the page."

So, starting in the 1960s there has been a story, a collection of work, a metaphor which has unfolded, shifting directions, changing, through different times or accents. Fashion "is written in the spirit of the moment and with a certain approach; it's a game, or it could even be the rules of the game since that is what sets the tone. But who defines the rules, since there is no underlying logic, just a sense of the situation?" This is also a way of subtly challenging the myth of the designer's programmed creativity: the magnificent but implausible legend of a designer who promotes a new line or flash of inspiration every six months, dogmatically ordaining shapes, colors and proportions. Always driven by the underlying profit motive.

a s her story evolves each new season, Rykiel offers only adjustments, silhouettes, potential revelations, transitory images: "Clothing is like a memory, it summons up themes from the past. The polka-dot dress I wore when I was pregnant with Nathalie, the blue dress I wore when I was expecting Jean-Philippe, these are suggestions, reference points."

These recollections thrive in the nurturing warmth of the

present. Fractions or shards that capture a fleeting instant for eternity; the genius of the moment. And Rykiel is just as aware of the demands on today's designer, who, like the rest of us, is subject to the crazy pace of events, the exaggerated value attributed to speed, the exaggerated rhetoric, the proliferation of labels and fads, and the general confusion that ensues. "The multitude of new fashions (a modern phenomenon) forces the designer to 1) play his cards close to the vest, 2) overbid the competition (dangerous but profitable), 3) work with diamond-cut precision.

f orced to chase after novelty—in itself, a manifestation of this obsession with speed—the designer becomes the victim of a paradox: "The designer is pulled in two directions because she must be at once 'ahead of the times', and 'with it', and at the same time she must retain her role in history, because she is a witness to it. So she must have a vision that is both clearer and broader. The designer faces the paradox of playing with the time past, present, and future, transitions among these three periods, the way the past bears on the present and is folded into the future, without adding unnecessary creases."

As a result, the modern designer is hungry for information, insatiably curious, always looking for another sign, one more thought, a fresh mode of expression: this is the central paradox of contemporary fashion, where the obsession with originality feeds off borrowings and eclecticism and is nourished by converging echoes and reminiscences—"fashion takes from everywhere." Like a drum, it has a resonating chamber that vibrates with the slightest breath,

stores input, then dissects it, lays it out, and transmits it in its own way. We know that there have been occasions when two designers who have never seen or spoken with one another release collections based on very similar themes. Why? Because they are inspired by the same things at the same moment—a movie, a book, a joyful or tragic event in the world.

And this is why Sonia Rykiel and a few others have such an insatiable need to engage in multiple activities. Moving from writing (always extremely important to her) to drawing, from drawing to fashion, from fashion to reading, allows her a fresh perspective, a shift of focus, the chance to recharge one activity with the energy from another.

t he fluid mesh of a sweater, the drape of jersey, the frothy lightness of *grain de poudre* or crêpe: the designer favors materials that share paradoxical qualities—airiness and weight, fluidity and structure. They are best suited to the Rykiel silhouette, elongated and clinging, though never tight, supple though never drooping. Her dresses, skirts and cardigans flow with movement, following the body without hugging it. The essence of Rykiel's style is the very definition of elegance—the concept of subtly tinted designs, best when worn without self-consciousness, following the true center of gravity, the body's own inherent grace.

It is precisely this awareness of the body and its insistent presence that inspires and sustains Rykiel's creativity, a kind of obsession with the skin itself. In 1974, she was the first (but is there ever really a "first" in fashion?) to design clothing that could be worn inside-out, turning over this second skin, showing visible outside seams, "deconstructing" clothing in a way that inspired

numerous designers, particularly the Japanese, over the next few years. But her idea was nothing revolutionary in itself; she never aimed to topple the basic structure of fashion, to abolish its rituals, or renounce traditional rules.

Sensuousness remains a characteristic of Rykiel's clothes. She illuminates the parts of a garment that touch, brush or caress the skin as it moves, dwelling upon the unconscious, ordinary feeling of clothing, reversing inside and outside, playing with the mirror images of concealment and revelation. "I want to find a balance between what is inside and what is outside, while emphasizing that which is within. The body should dominate its covering. I want to invent a collection of clothes that reveals the body and that lets the spirit and the love of the body shine through, a mirror worn on top that reflects the body beneath. I turned the clothing inside-out and I showed that the other side of the garment, the part that touches the skin, the inside, was more beautiful because it was outlined with seams that resemble the vaults of a cathedral. I filled it with symbolic value. Worn inside-out, your sweater is a gift."

Step by step, we find ourselves at the heart of Rykiel's creativity. Designed by a woman for a woman, her style is profoundly ambiguous, conceived as a play on gender. For her, femininity can only be discerned in the shadow of masculinity, and vice versa. Neither sex has its own essence, its own purity, its own set of laws. Each is defined only by closely overlapping, interweaving, reshaping each of its own "natures." "There are no strict rules in fashion. You have to be able to find a use for everything: enter into your own mold, recast the molds of others and project a unique image that blends both yourself and others."

15

as Rykiel conceives it, fashion is essentially strategic: it has a keen and immediate sense of its audience, it speaks to the individual, it seeks a responsive glance. Although we rarely think about it, this is one of the basic purposes of clothing, certainly as important as its primary protective function. But this topic is rarely addressed in discussions on fashion or by fashion itself. Perhaps only a woman could so uncompromisingly express this silent consciousness of clothing, this ability to evoke the body, to reveal through a veil.

"To be a woman in design is like putting on a performance. You are deluded if you think you are closer to a woman's body just because you are a woman. But being a woman can still present problems: you stop because you know that you can't go any further, that the next move isn't possible. So you ease off, you let it out or even reconfigure. A male designer has never been inside the outfit, so he doesn't ease off or let out. His imagination ranges farther because he doesn't sense the limits; he will never enter within. A woman limits herself, she stitches, he pins together. She sees stitches, he sees pins. With pins you keep things open, with thread, you finalize them."

An awareness of limits and the need to be liberated from them. A few years ago the novelist Alison Lurie wrote *The Language of Clothing*, where she describes how people express their choices, their rejections, a sort of personal glossary. She reviews how they present themselves, display their affiliations, their social nature, their own histories. But a dimension is sadly missing from this positive, assertive vision of fashion, an element that stands at the heart of Rykiel's creation: this personal "language" is above all a

deception, a constraint, a trick on yourself, and thus on other people. "Fashion is a tug-of-war game between knowing yourself and acting a part. To seduce yourself, to be your own mirror, to deflect the truth in order to emblazon a trompe l'oeil portrait on fabric, a portrait that is only slightly distorted since the pleasure of printing your own image on the material is far from innocent."

Mysterious balance, silent punctuation, the conflict of self-effacement and self-promotion, the delights of deception. For Sonia Rykiel, appearances are what you must alter first; her creativity wells up from this intimate certainty, from this simple attribute of human nature. The essence of her work is summarized in a few ephemeral details: the sliver of skin that separates a glove and the edge of a sleeve, so dear to Pierre Klossowski, the bareness of a low neckline, the subtle cut that lures the hand to touch it, the caress of a fabric that invites a caress—in short, the witty interaction between the body and an attentive gaze.

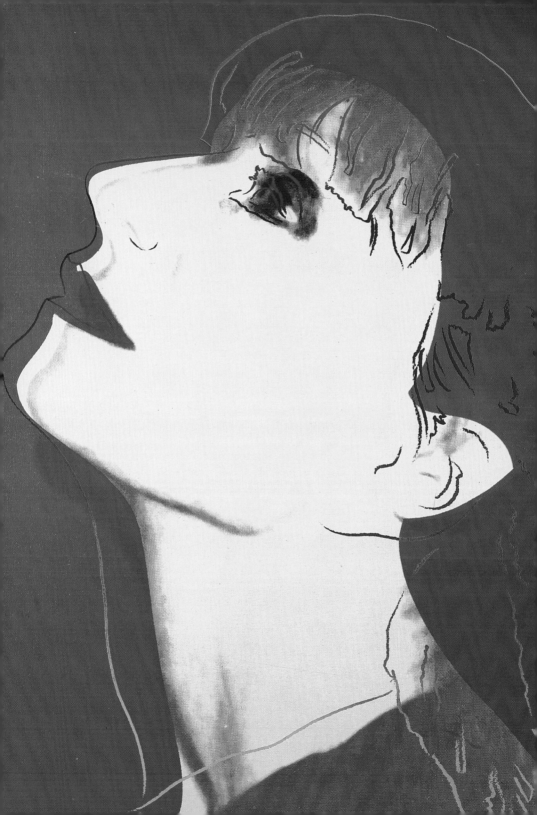

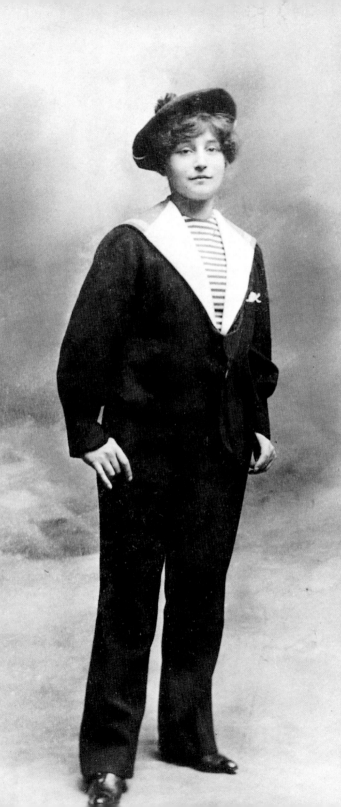

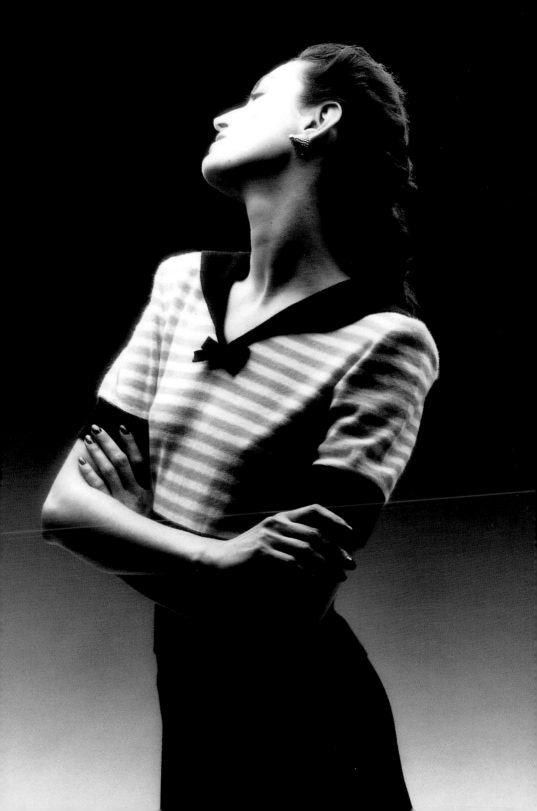

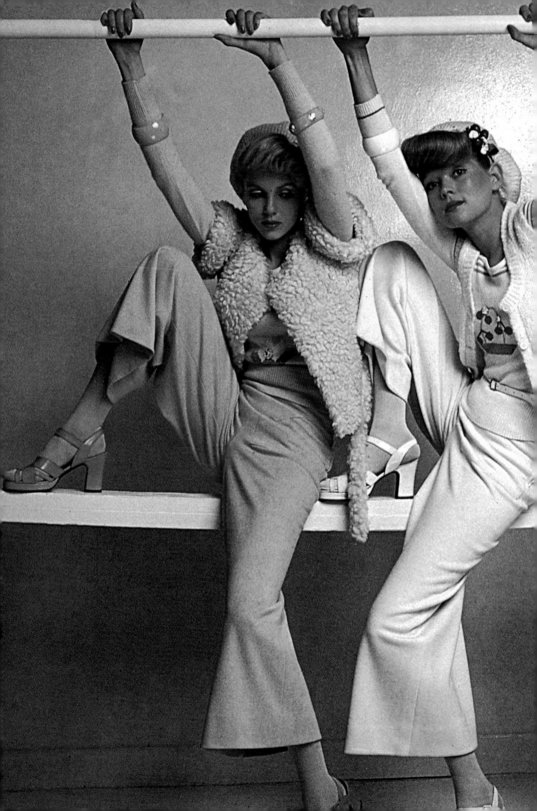

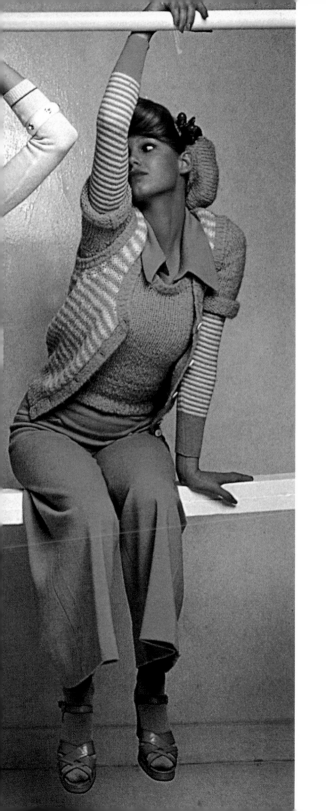

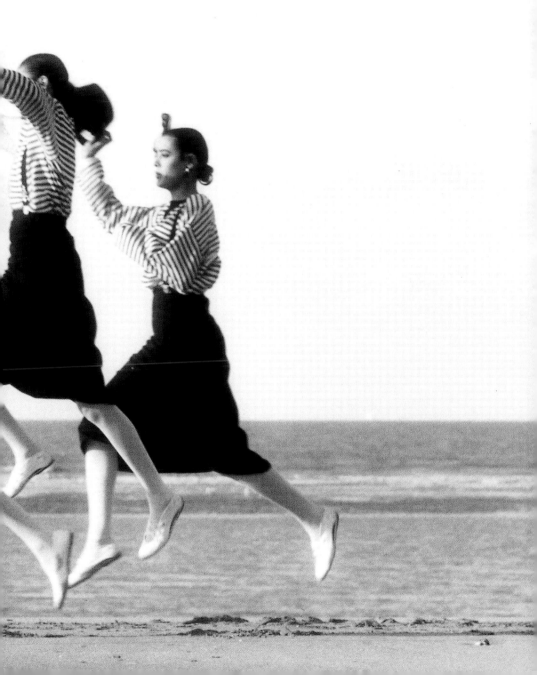

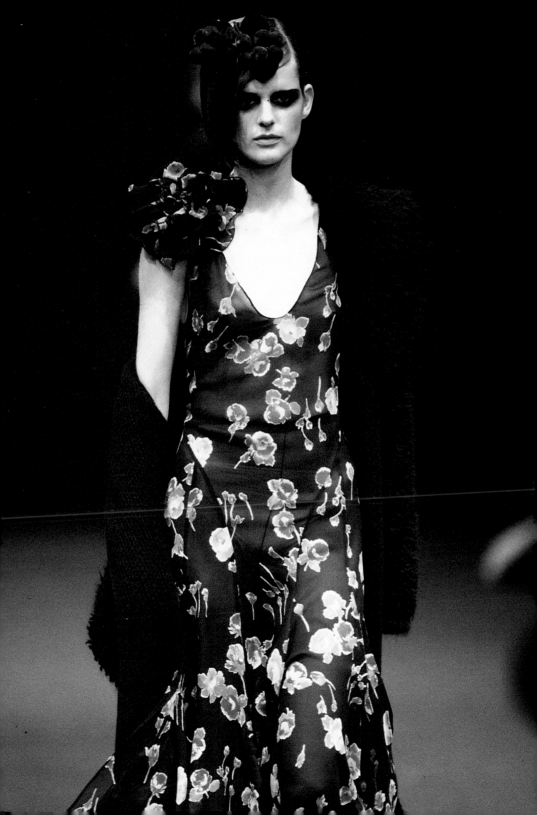

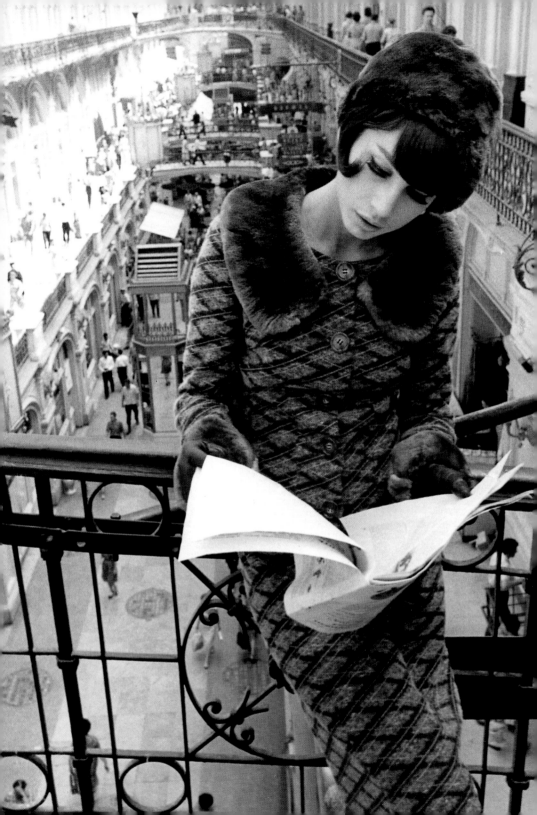

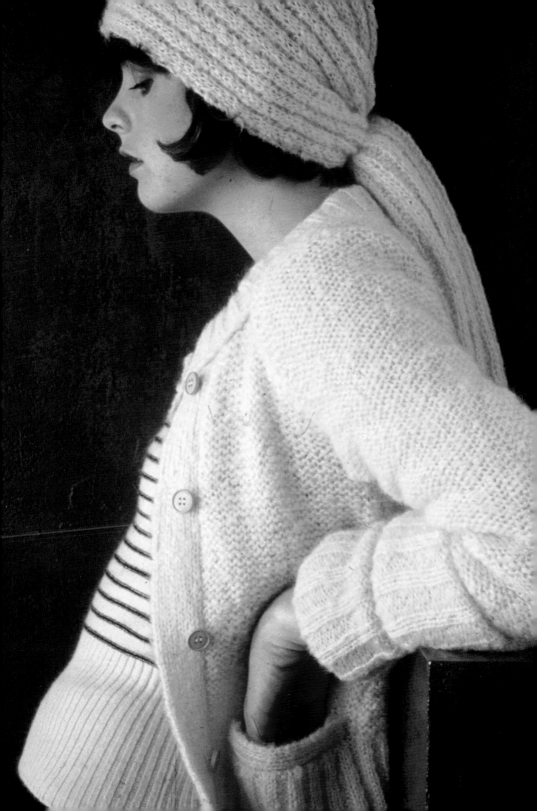

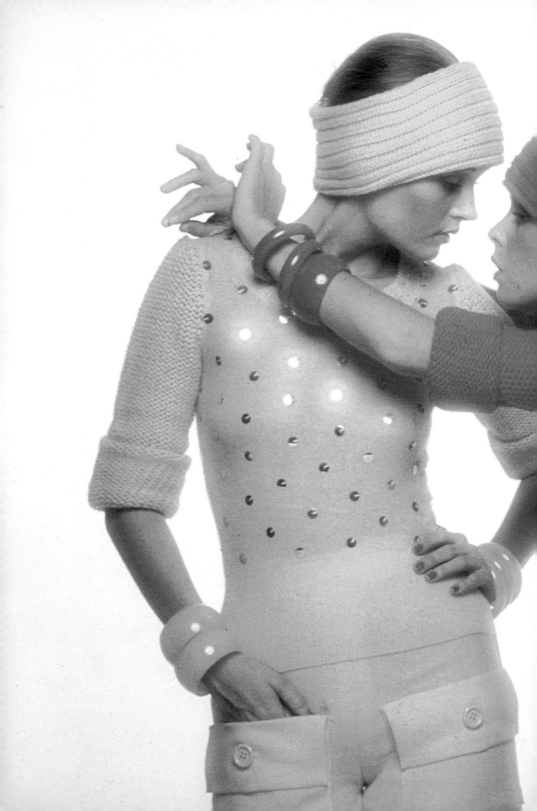

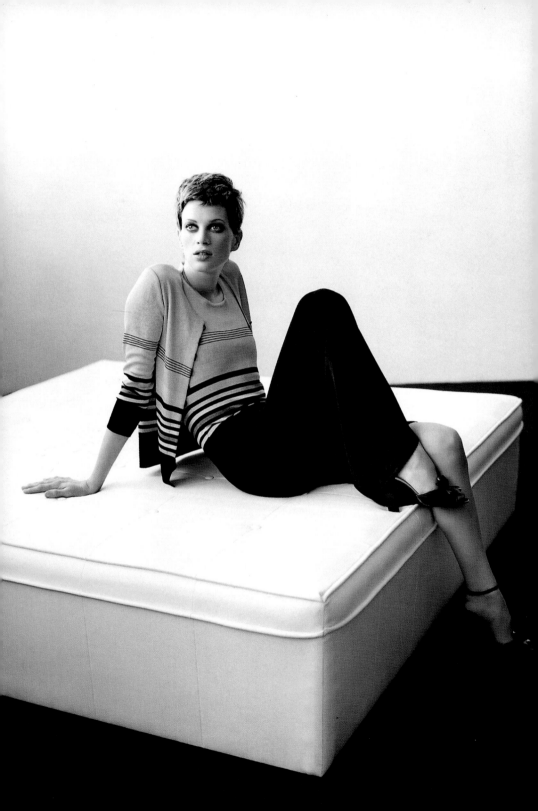

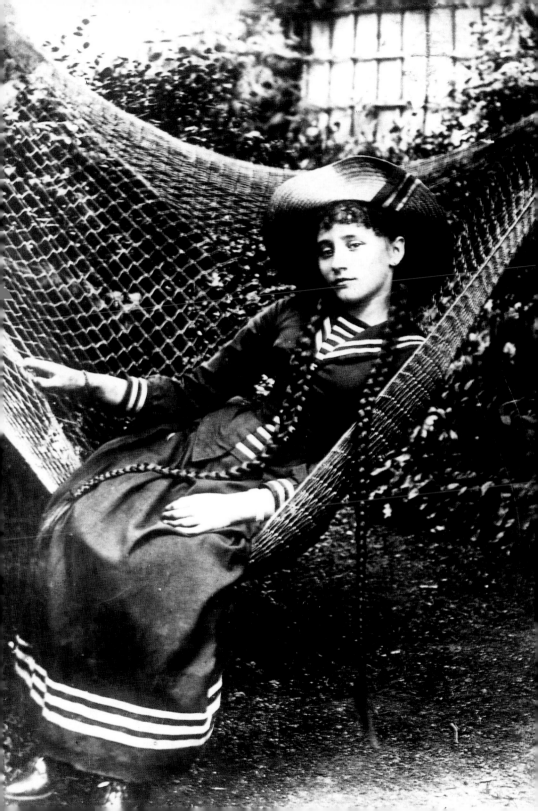

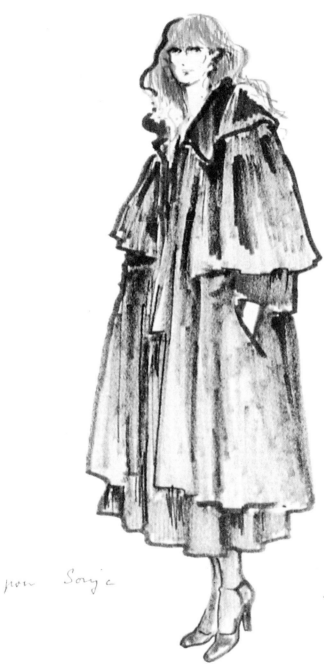

pour Sonja

1ᵉʳ mai 1974

Karl

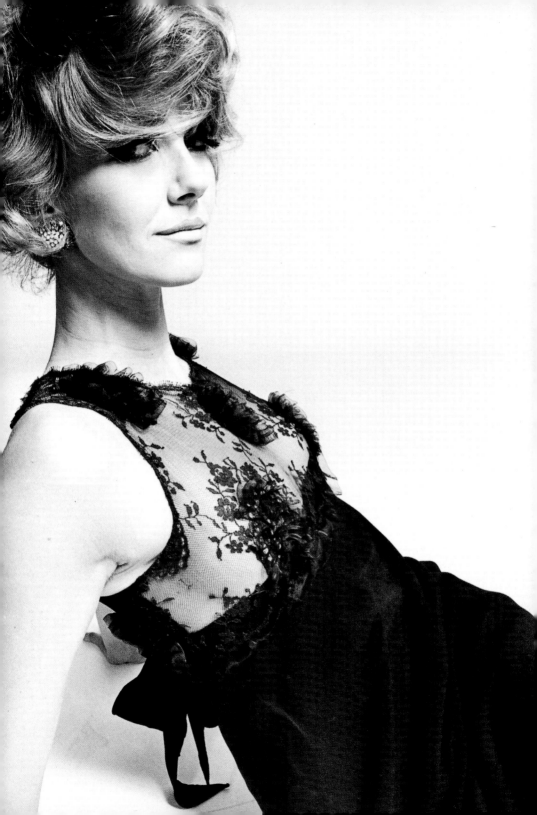

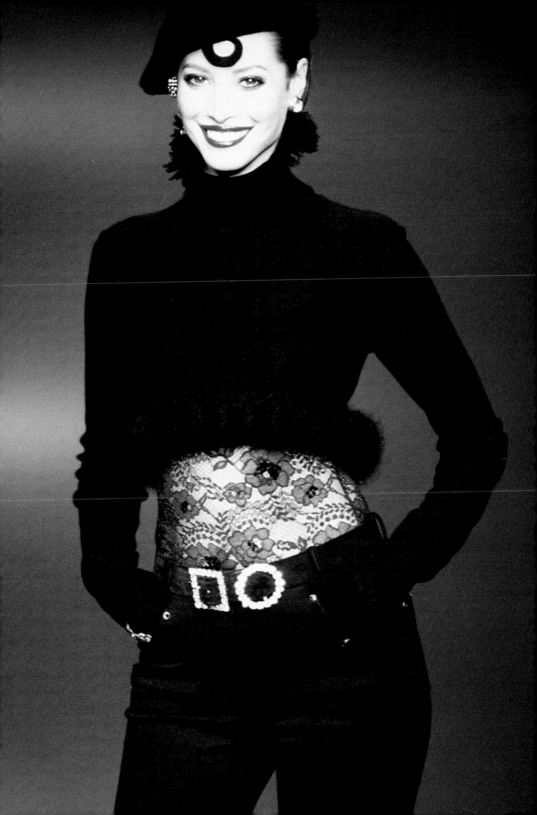

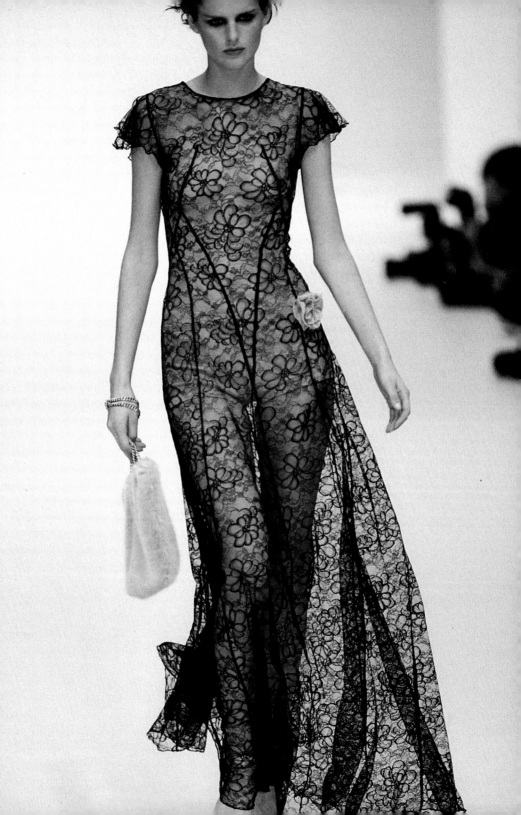

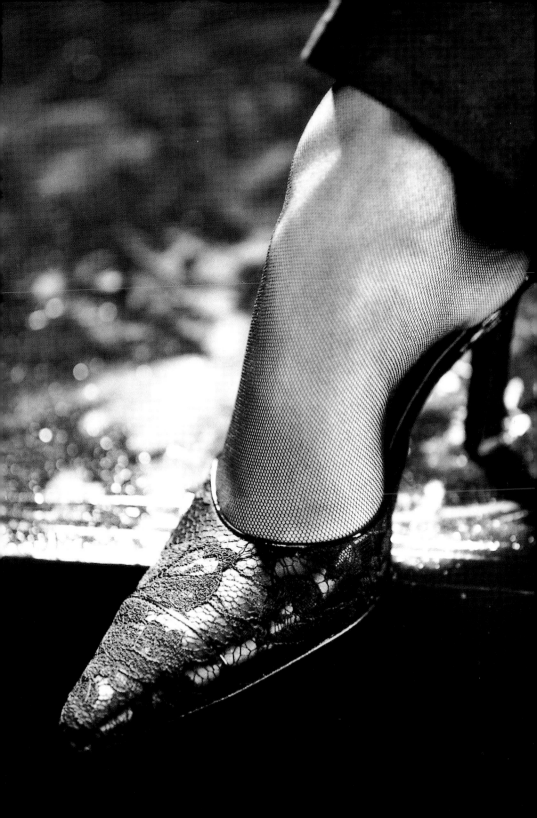

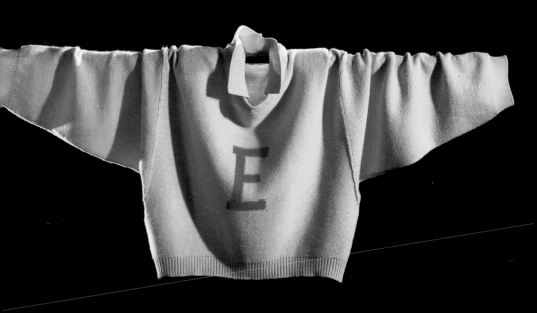

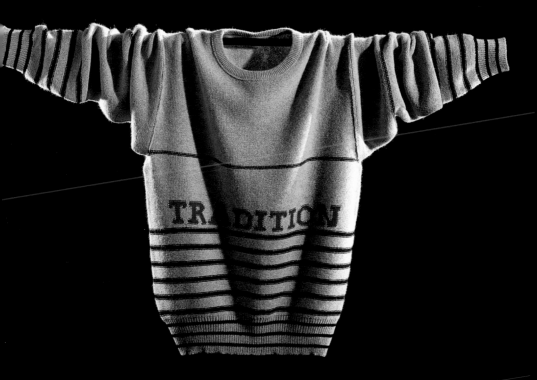

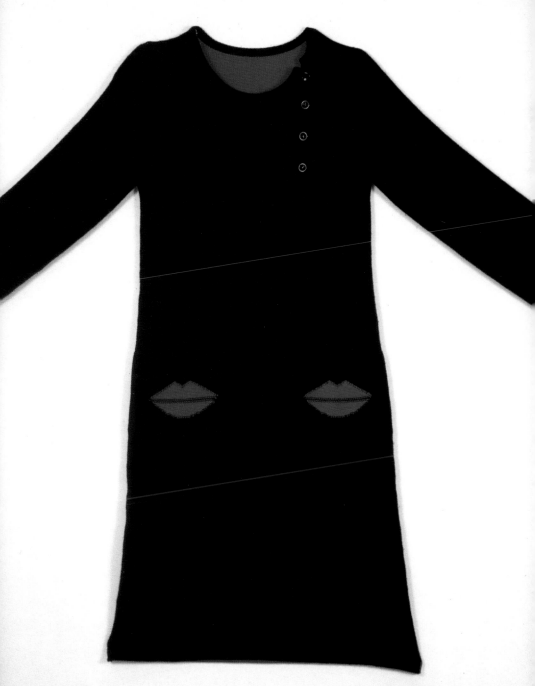

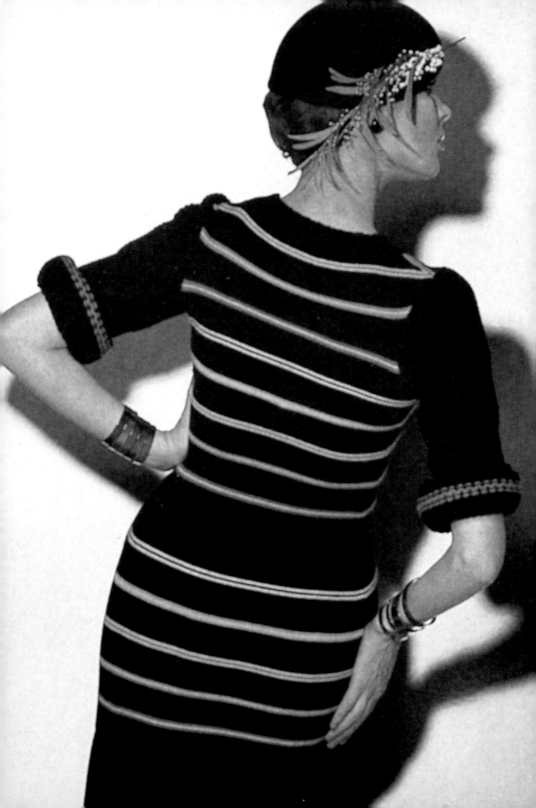

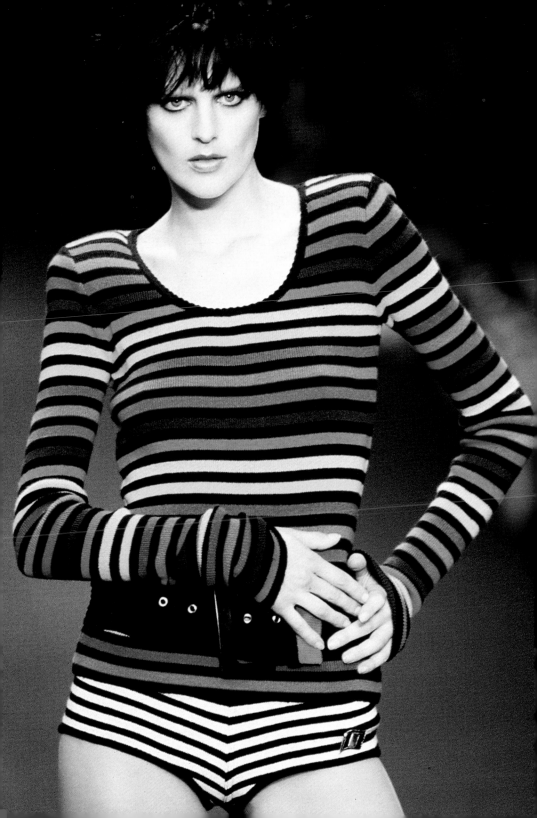

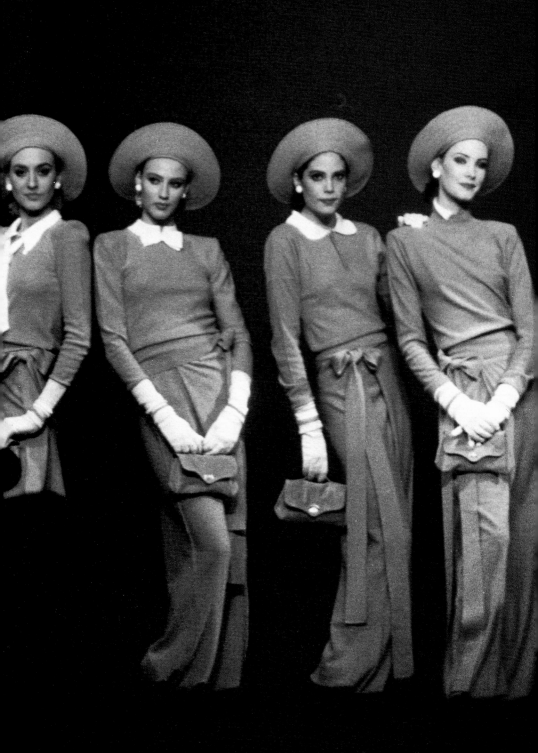

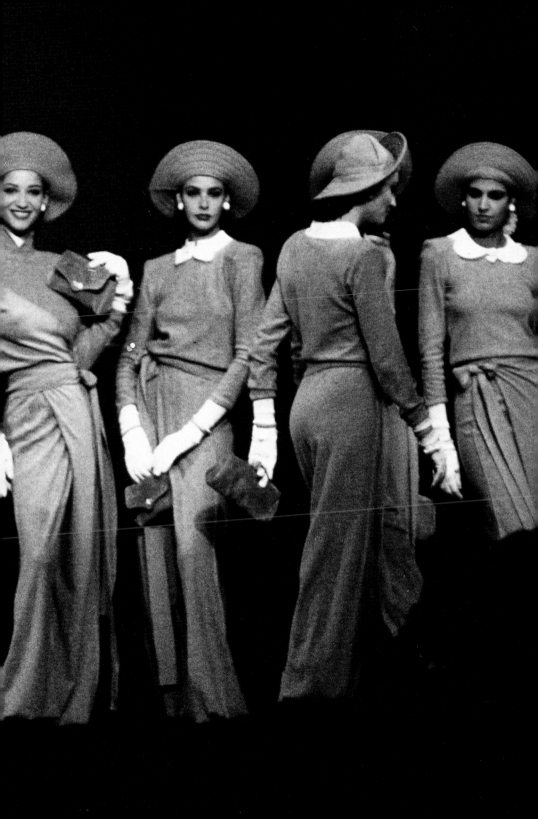

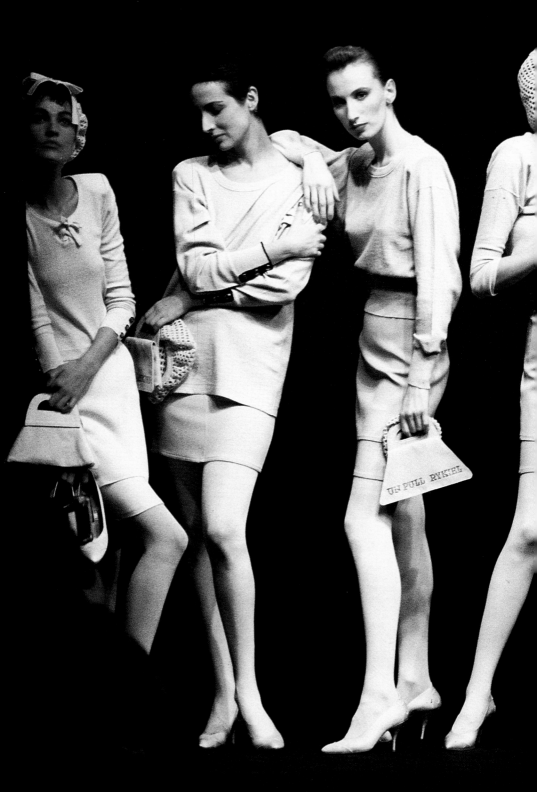

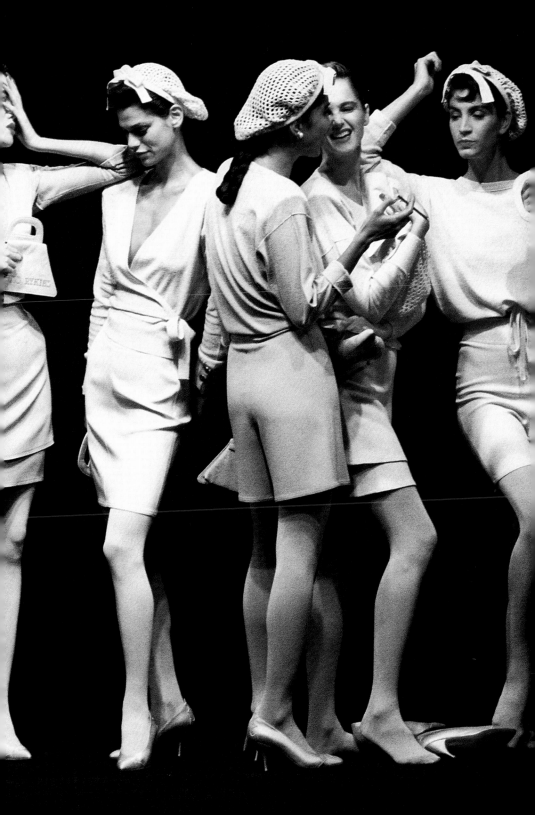

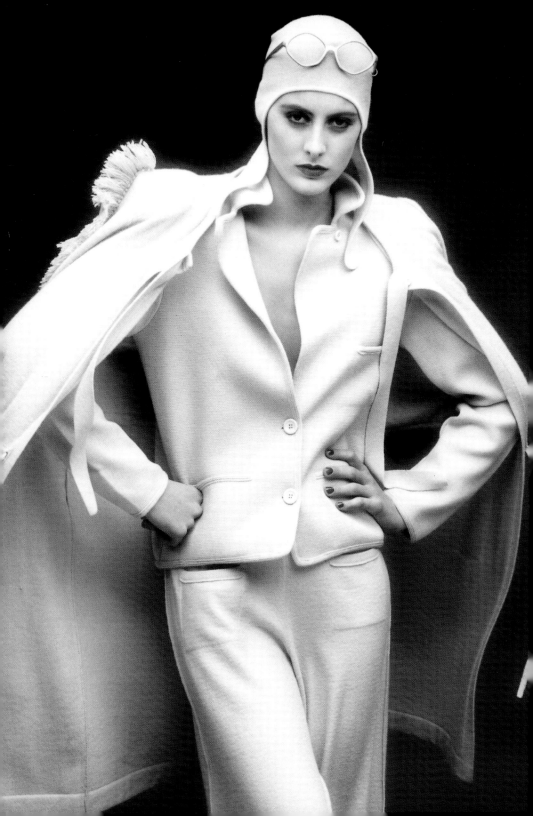

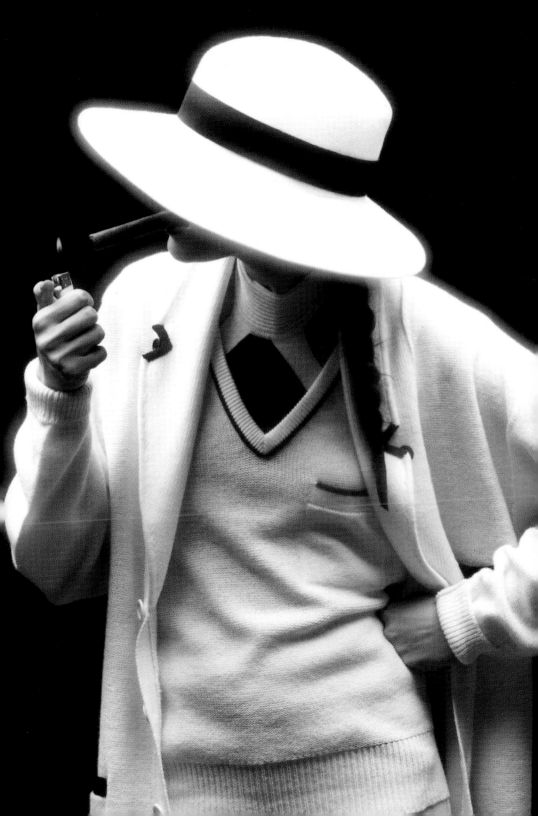

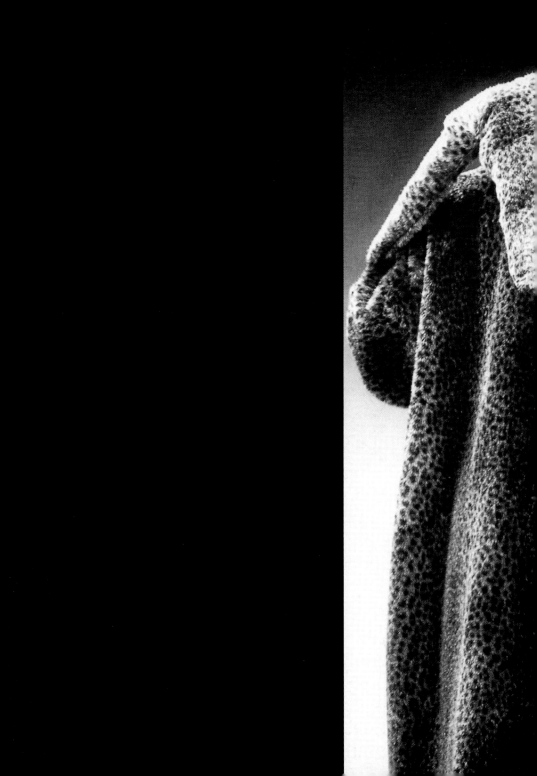

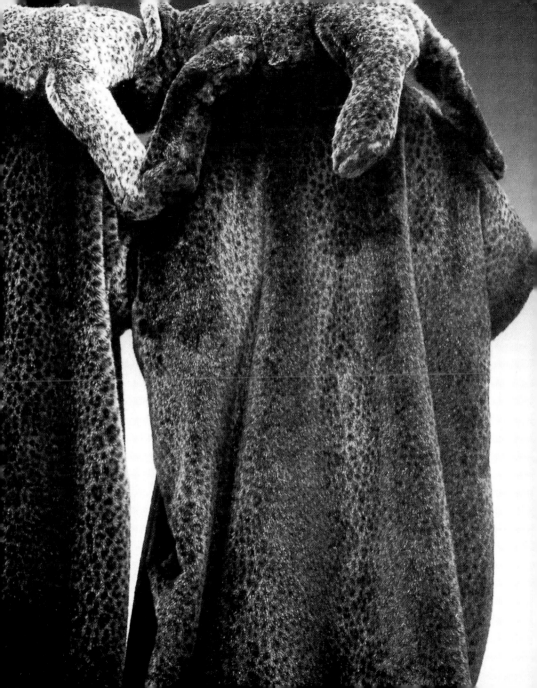

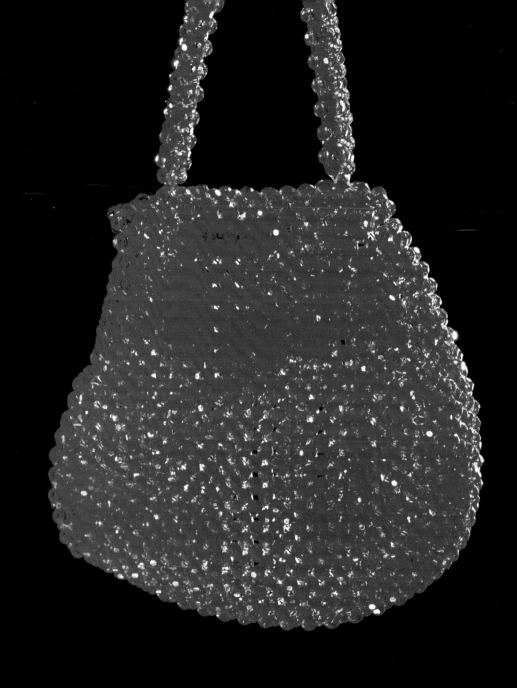

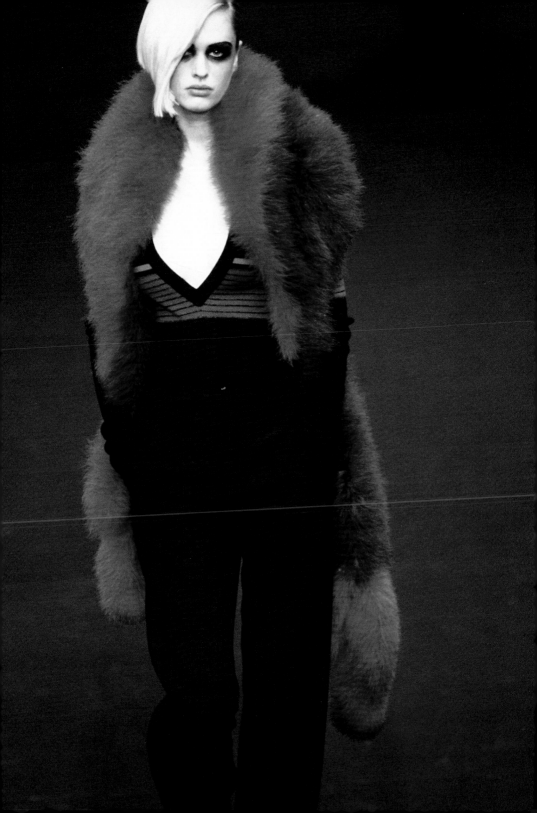

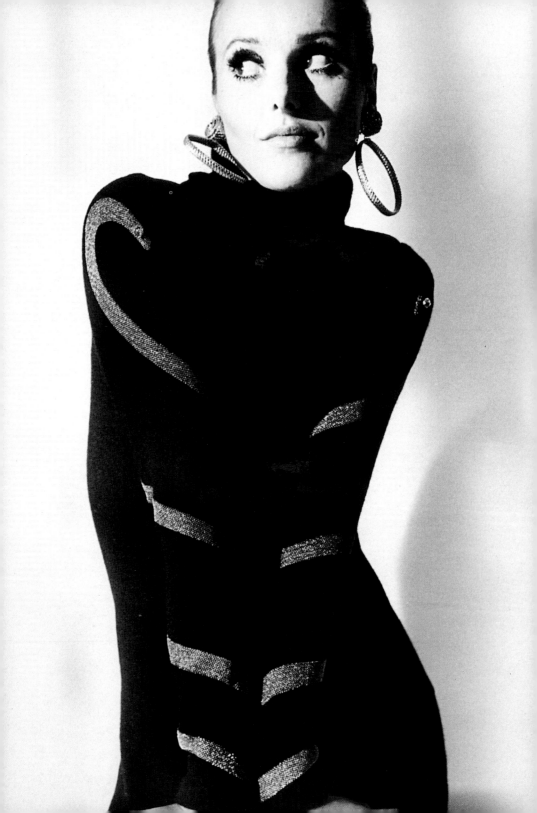

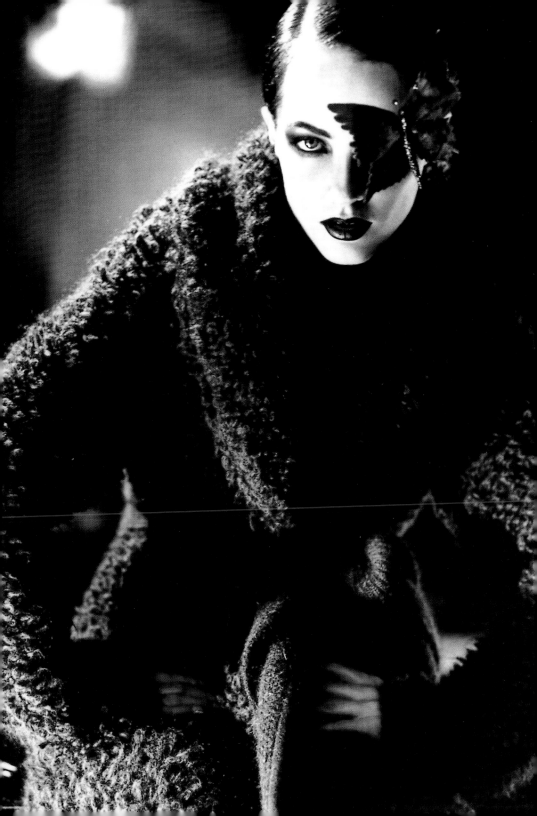

paillette
+
rayure

faux
dessin

bordure 2/2

Reprendre le
corps .XX=

Rajoute
de puls
blanche
ou
jaune

Resille
rayée

LUTETIA
XX

carte pour
N. Gala .

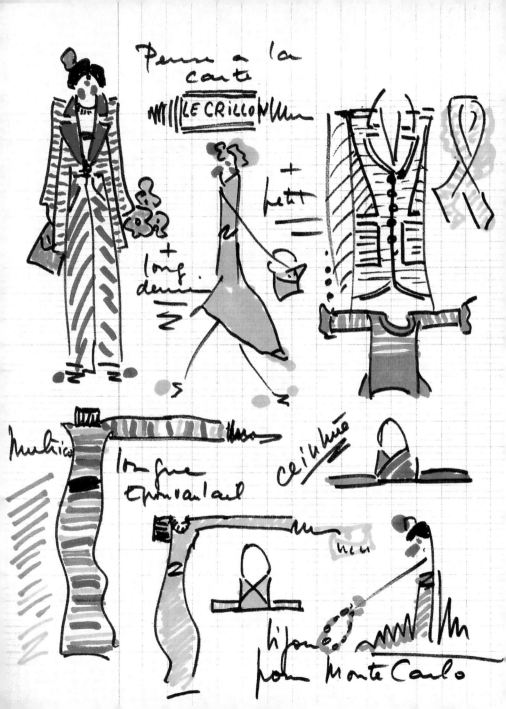

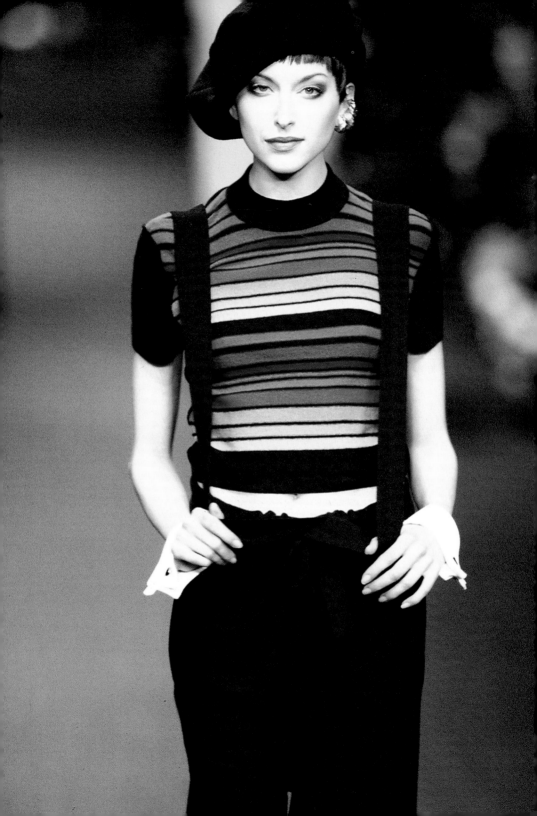

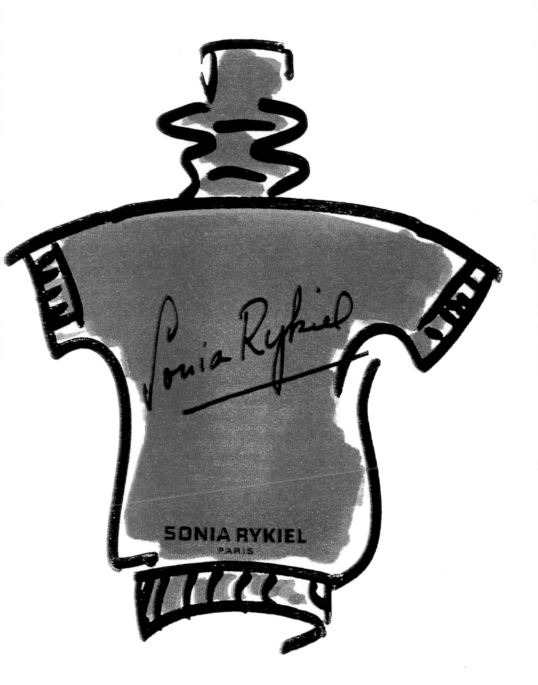

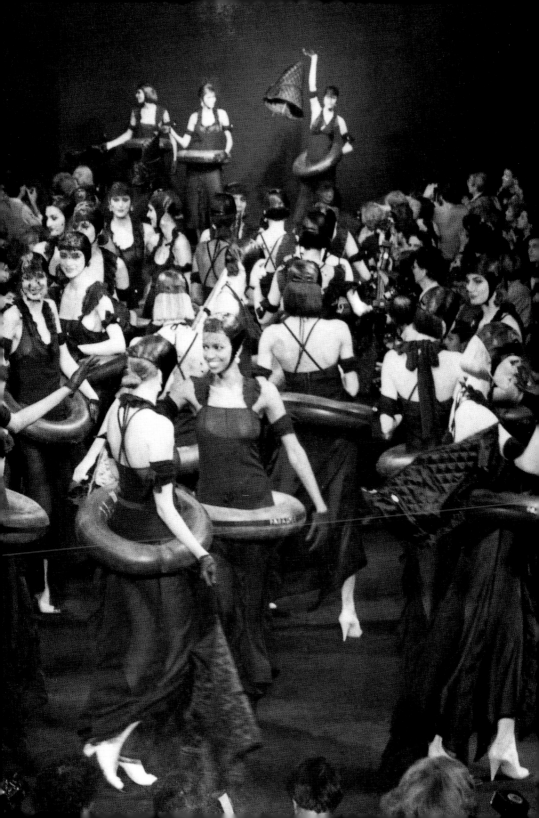

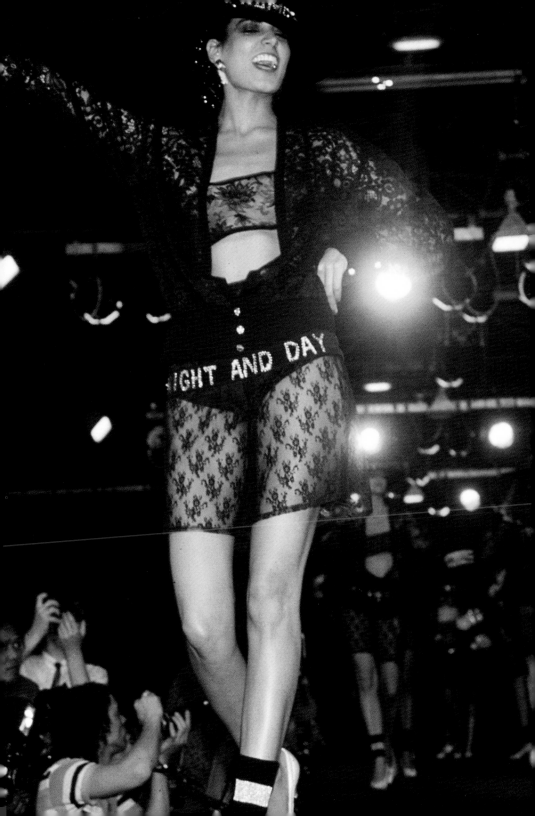

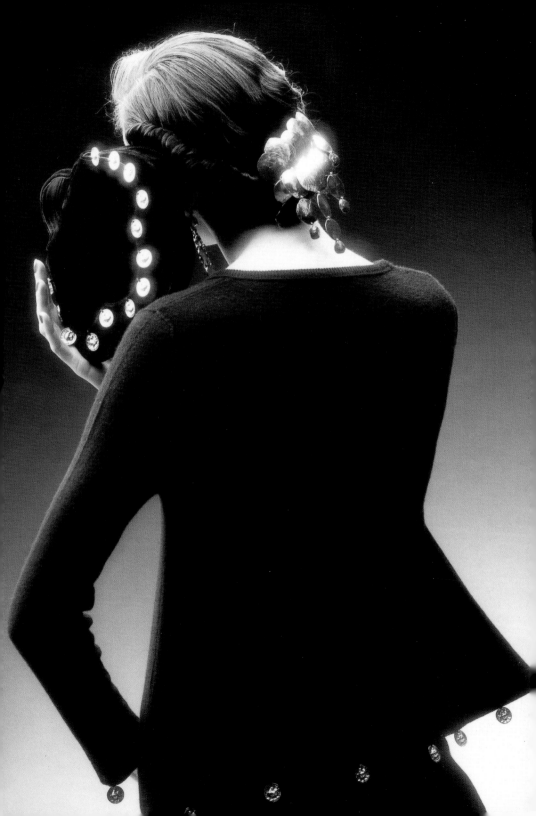

Chronology

1962 : Sonia Rykiel creates her first maternity dresses and clingy knits for the 'Laura' boutique in Paris. They achieve an immediate success.

1967 : Her clothes are discovered around the world. The Americans dub her the "Queen of Knits."

1968 : Establishment of Sonia Rykiel C.D.M. and opening of her first boutique in Paris on theLeft Bank, in the heart of the Saint-Germain-des-Prés district.

1973 : Elected vice president of the Chambre Syndicale Française du Prêt-à-Porter des Couturiers et Créateurs de Mode, a position she held until 1993.

1974 : Invention of clothing that could be worn inside-out.

1976 : Her new style is labeled "démode": women are encouraged to wear her clothes however they choose, adapting them to their own style.

1977 : Sonia Rykiel is the first fashion designer to create clothes exclusively for the mail order catalogue *3 Suisses*.

1978 : Creation under license of the first women's perfume called '7è Sens'.

1979 : Represents France at The Women in the Year 2000 Conference in Japan. Publication of her first book *Et je la voudrais nue...*(Grasset).

1980 : Elected one of the world's ten most elegant women.

1982 : Redesigns the interior of the Hôtel de Crillon, one of the most prestigious hotels in Paris.

1983 : The French minister of culture, Jack Lang, decorates her as a Chevalier of the Ordre des Arts et des Lettres.

1984 : Creation of the first 'Sonia Rykiel Enfant' collection.

1985 : Awarded the Légion d'honneur by François Mitterand. Receives the jury's Special Oscar at the first fashion Oscars. A photographic collection called 'Rykiel' commemorating her first twenty years is published by Herscher.

Black 'trapeze' sweater in wool and angora with gold snakes, calfskin purse with gold sequins, hair clip with gold sequins, Spring/Summer 1989. © Dominique Issermann.

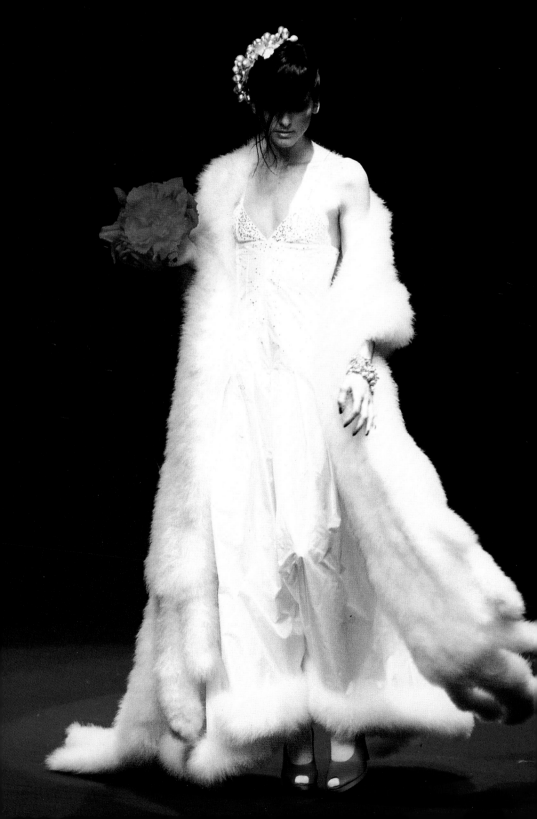

1986 : Receives an Oscar from the Fashion Group of New York.

1987 : Exhibition 'Sonia Rykiel, 20 ans de Mode' at the Galeries Lafayette department store. Creation, under license, of the Sonia Rykiel Night and Day cosmetics line in Japan.

1988 : Publication of her anniversary book, *Célébration*, featuring twenty years of fashion history illustrated with her drawings and text. (Éditions des femmes).

1989 : Her daughter, Nathalie, presents the first 'Inscription Rykiel' collection. Her book *La Collection* is published by Grasset.

1990 : Designs her new flagship store 'Sonia Rykiel' on boulevard Saint-Germain in Paris. Launch of the 'Rykiel Homme' collection.

1991 : She illustrates the book *Colette et la Mode* for Éditions Plume.

1992 : Presentation of first shoe and watch collections.

1993 : Her children's book *Tatiana Acacia*, illustrated by Charles Matton, is published by Flammarion. The Fashion Foundation invites her to present her 1993 Fall/Winter line in Tokyo for the Virginia Slims collection. She gives a series of talks to Gakuen fashion students in the major Japanese cities. Presentation of 'Le Parfum Sonia Rykiel'. Celebrates twenty-five years of design at the Palais de Luxembourg where the minister of culture decorates her as an Officier of the Ordre des Arts et des Lettres. Her book *Collection terminée, collection interminable* is published by Flammarion.

1994 : She designs Anouk Aimée's clothes for her role as an international fashion designer in Robert Altman's film, *Prêt-à-Porter*. Launch of the first line of bath products based on 'Le Parfum Sonia Rykiel'. Receives the Award for Design Excellence from the Chicago Historical Society's Costume Committee in November.

1995 : Creation of a Forge de Laguiole knife. Launch of the Sonia Rykiel rose, designed by the rose grower Pierre Guillot.

1996 : For the 'Janvier en Bourgogne' event, a special show is dedicated to Sonia Rykiel at Châlon-sur-Sâone where she sponsors twenty youths as apprentices for a one-year program in the fashion industry. Decorated as an Officier of the Légion d'honneur. To celebrate the tenth year anniversary of 'Sonia Rykiel Enfant' she joins up with Enfance et Partage. She designs a line of china. Her book *Les Lèvres rouges* is published by Grasset. Opening of the Sonia Rykiel boutique in New York on Madison Avenue.

1997 : Launch of her new perfume 'Sonia Rykiel'. The department store Bon Marché organizes a major Sonia Rykiel show.

Wedding dress, trouser suit in ivory taffeta trimmed with pale rose and natural marabou, Winter 1995-96. © Graziano Ferrari.

Sonia Rykiel

Portrait of Madame Rykiel, 1986, acrylic and silkscreen, 101.6 x 101.6 cm. Her fiery qualities as seen by Andy Warhol, one of the artist's last portraits. © ADAGP, Paris, 1997.

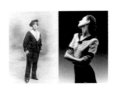

Colette in a sailor suit. © D.R.
Striped wool and angora knit top with sailor collar. Summer 1995-96. © Dominique Issermann.

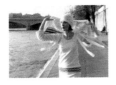

Striped wool and angora white pullover, Winter 1975. Photo Uli Rose. © Marie-Claire.

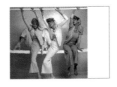

Patterned wool and angora pullovers decorated with rhinestones, mohair jackets and jersey trousers, Winter 1971. Captured by Guy Bourdin, the perfect image of the 1980s and the enthusiasm for kids' clubs.
© Guy Bourdin.

Sonia Rykiel. Libération, April 1987. © Dominique Issermann.

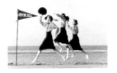

Striped knit tops with knit skirts, Spring/Summer 1987. An adaptation of the sailor look, emphasizing the body's movement. © Dominique Issermann.

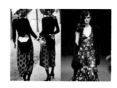

Black wool and angora tops, silk skirts, patterned wool and angora sweaters worn around the waist, Summer 1972. Photo Elisabeth Novick. © D.R.
Black floral mousseline slip dress with long black mohair coat, Fall 1997.
© Xavier Raux.

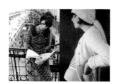

Black jersey quilted suit with fake fur collar, Winter 1964. Photo Lionel Kazan. © *Elle*/Scoop.
Pink wool and angora sweater with black stripes, jacket in pink mohair, Winter 1973. Between 1964 and 1973, some patterns remained unchanged, others were transformed and shown again. © Steve Hiett.

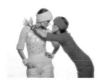

Wool and angora pullover with paillettes and lurex, jersey trousers, Winter 1973. Photo Duc Nguyen for *Marie-Claire*. © Duc Nguyen.

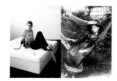

Sleeveless dress in striped viscose knit with matching cardigan, Spring/Summer 1996. © Mario Testino.
Colette about 1892. Fashion is the mirror image of literature, or perhaps its continuation by other means...Colette, paragon of sensuality. © Harlinque-Viollet.

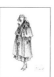

Collection of drawings of Madame Rykiel: (from left to right) Karl Lagerfeld, Régine Déforges, Claire Brétecher, Wiaz. Right: Karl Lagerfeld.
© Sonia Rykiel Archives.

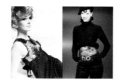

Crêpe dress with lace top, 1964. Photo Horn Griner for *Elle* 1964.
© *Elle*/Scoop.
Short wool and angora knit sweater, black lace body stocking, black crêpe trousers, belt with rhinestone buckle, Fall/Winter 1994. Thirty years later, another play on exposing the body. © Graziano Ferrari.

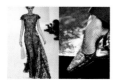

Long dress in chantilly lace with dusty rose shorts. Pink fake fur purse, Spring/Summer 1997. © Xavier Raux.
Satin and lace sandals, with patent leather ankle straps, Fall/Winter 1997-98. The contrasts between the transparent, concealing and revealing aspects of lace is played out down to the smallest details on a pair of low-fronted shoes.
© Mario Testino.

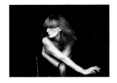

Sonia Rykiel. Photo by Dominique Issermann for *Vogue*, August 1980.
© Dominique Issermann.

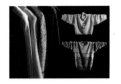

Sweater series: yellow wool and angora sweater with letter 'E' motif, Summer 1985. Long beige, black and blue wool sweater with 'Tradition' motif, Winter 1984-85. © Laziz Hamani.

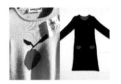

Short wool and angora sweater with apple motif. Fall/Winter 1972-73.
© Laziz Hamani.
Wool and angora dress, mouth motif. Winter 1977. Playful designs with messages: motifs on sensual knits. Photo Béatrice Hatala. © D.R.

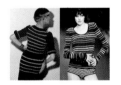

Long striped wool and angora dress with high neck, thick wool sleeves.
Photo Alain Vivier. © *Elle*/Scoop.
Multicolored striped wool and angora knit top, black and white wool and angora shorts, black knit belt, Spring/Summer 1996.
© Xavier Raux.

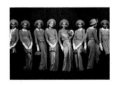

Knitted wool and angora sweaters, selection of wool and angora trousers, jersey hats, Fall/Winter 1987-88. Emphasis on the fluid draping of wool and angora, the feel of jersey. © Graziano Ferrari.

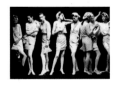

Wool and angora sweaters and dresses worn with crêpe skirts and Bermuda shorts, Spring/Summer 1988. Infinite variations on asymmetry, subtly accentuated by the use of wool and crêpe. © Graziano Ferrari.

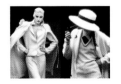

Beige jersey suit and beige wool and angora coat, Spring/Summer 1981.
© Dominique Issermann.
Long knit cream cardigan worn over a low-cut V-neck sweater, Fall/Winter 1980. © Dominique Issermann.

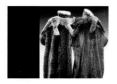

Coat with fake fur baby leopards, Winter 1984. Fake is always better than the real thing. © Dominique Issermann.

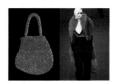

Red pearl purse, Summer 1997. © Laziz Hamani.
Plunging V-neck knit and angora sweater with wool crêpe man's trousers, red marabou feather boa, Fall/Winter 1997. Depth of color and sensuality reflected through use of red, a continuous theme of this creative redhead. © Xavier Raux.

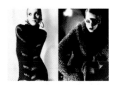

Angora and wool dress, gold lurex snake motif, Winter 1966. Photo Daiho Yoshida for *Elle* 1966. © *Elle*/Scoop.
Plum-colored mohair coat, Fall-Winter 1997-98. © Mario Testino.

Madame Rykiel's notebook drawings. Daily inspirations.
© Sonia Rykiel Archives.

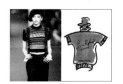

Striped wool and angora sweater, knit trousers with suspenders, Summer 1994. © Graziano Ferrari.
Sketch of 'Sonia Rykiel' perfume bottle designed by Madame Rykiel. Sonia Rykiel's signature sweater served as the model for her latest perfume bottle, April 1977. © Sonia Rykiel Archives.

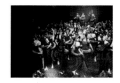

Finale: Dresses in silk mousseline with quilted satin jackets, Summer 1984.
© Francis Kompalitch.

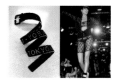

Black velvet belt studded with rhinestones, Winter 1989. © Laziz Hamani.
Lace bra and blouson, lace shorts with satin underwear, Summer 1983. A nod to the end of the disco era? And the sequins are the real thing.
© *Marie-Claire.*

The publishers would like to thank the Maison Sonia Rykiel and the publicity department for their assistance in producing this book and most particularly, Safia Bendali. We also wish to thank Dominique Issermann and Mario Testino. Finally, this book could not have been published without the wonderful help of Samuel Bourdin (Guy Bourdin), Madame Lajournade (Roger-Viollet), Nicole Chanson (ADAGP), Claudine Legros (*Elle*/Scoop), Gwenaëlle Dautricourt (*Marie-Claire*), Alexandra (Dominique Issermann), Amber and Édouard (Mario Testino) and Véronique Rampazzo (Marilyn Gauthier).